D0099759

AIN'T GOT TIME TO BLEED

MEDICAL REPORTS ON HOLLYWOOD'S GREATEST ACTION HEROES

by Andrew Shaffer

Illustrations by Steven Lefcourt

INSIGHT EDITIONS

San Rafael, California

CONTENTS

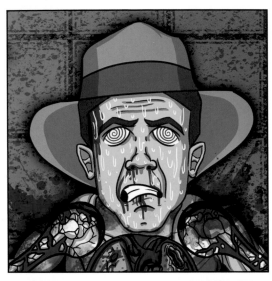
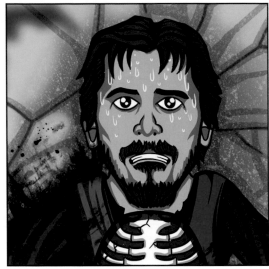
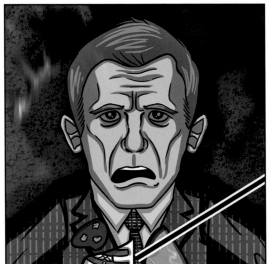
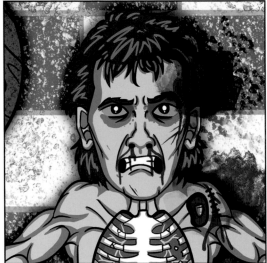

INTRODUCTION

Big-screen action heroes get shot, stabbed, and blown off their feet by explosions. They punch, kick, and head-butt endless hordes of bad guys. They jump from airplanes without parachutes and walk barefoot through broken glass.

Thanks to the magic of Hollywood, these larger-than-life characters always survive their thrilling ordeals—often unscathed. It's rare to see a leading man or woman limp for more than a scene or two, even after fracturing an ankle. Pain? As Patrick Swayze's tough guy James Dalton famously says in *Road House*, "Pain don't hurt."

But what would happen to these human pincushions in real life? How many windows could they *really* jump through before they were carved up like Thanksgiving turkeys?

In this indispensable guide to action hero injuries, fact-checked by actual medical professionals, you'll learn the answer to such burning questions as:

- Is it possible to exit an airborne plane on a life raft and float to safety, or would Indiana Jones have met his doom?

- Would the Dark Knight rise after his back was broken by Bane?

- Could James Bond survive his towering plunge into the river in *Skyfall*, or would it be time for a new 007?

Medically accurate and scientifically sound, this book is for anyone who's ever wondered if *Die Hard*'s John McClane could really jump from the roof of a high-rise with a fire hose around his waist and still save the day.*

*The short answer is "Not a chance in hell." For the long answer, turn to page 16.

JASON BOURNE

SCENE OF INCIDENT: *The Bourne Identity* (2002)

OCCUPATION: CIA assassin

INCIDENT REPORT: Amnesiac gunshot-wound victim was found floating unconscious in the Mediterranean Sea. Patient later set out on a journey of self-discovery across Europe, engaging in fistfights, shootouts, and car chases, using skills learned as part of a CIA black-ops program.

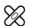 **INJURIES:**

1. **Back:** Shot twice with an unknown firearm before diving into the ocean to evade capture. Class IV hemorrhage (involving severe blood loss—i.e., over 40 percent of blood volume) causing hypovolemic shock (rapid heart rate, dangerously low blood pressure, and loss of consciousness). Possible infection of entry wounds by saltwater pathogens. Patient was rescued from the water by a passing ship; once aboard, a doctor stabilized his condition and removed the embedded bullets from his dorsum (back).

2. **Posterior right hip:** Small metal tracking device surgically removed. Incision with class I hemorrhage (involving minimal blood loss—i.e., less than 15 percent of blood volume).

3. **Head:** Psychogenic (dissociative) amnesia due to extreme psychological trauma. Complete loss of biographical and episodic memory. Patient's procedural memory—including his assassin training—remained intact.

4. **Hands:** Fistfights with multiple parties. Although amateur fighters may fracture bones throwing punches, it's likely the patient escaped with nothing more than a few bruised knuckles due to his training.

5. **Head, left shoulder:** Six-story fall broken by landing on a tumbling adversary. Superficial laceration on forehead. Anterior dislocation of the shoulder (glenohumeral joint) possible.

ADDITIONAL OBSERVATIONS: Patient suffers from recurrent migraines, which may be caused by post-traumatic stress disorder (PTSD) following his brutally intense black-ops training and high-pressure CIA missions. Other PTSD symptoms exhibited include flashbacks, severe anxiety, and hostility.

PROGNOSIS: Most injuries from blunt-force and penetrating trauma will heal within two to three months. PTSD symptoms will likely linger, requiring ongoing treatment (psychotherapy and/or medication). Bourne's memories may spontaneously return to him at any time—today, tomorrow, or years or decades down the line.

CONDITION: Partial recovery expected, at least from the neck down.

COLONEL JOHN MATRIX

SCENE OF INCIDENT: *Commando* (1985)

OCCUPATION: Delta Force colonel (retired)

INCIDENT REPORT: Retired Special Forces colonel waged a one-man war against a South American dictator who kidnapped his daughter. Patient sustained critical injuries during his rampage, which resulted in the grisly deaths of eighty-plus "bad guys."

INJURIES:

1. **Face, head, neck, back:** Multiple serious automobile accidents, including a head-on collision with a telephone pole and two rollover crashes. Superficial laceration on forehead. Probable traumatic brain injury (skull fracture, intracranial hemorrhage).

2. **Head, hands, thorax:** Fistfights with dozens of opponents. Beaten with a metal pipe, gun butt, and other blunt instruments. Another superficial laceration on forehead. Epistaxis (nosebleed). Bruised knuckles and fractured ribs likely.

3. **Abdomen:** Shot with a Palmer Cap-Chur short-range tranquilizer pistol. Minor puncture wound. Loss of consciousness.

4. **Knees:** Jumped from an airplane undercarriage and fell approximately one hundred feet into a muddy marsh, which cushioned his landing. Possible anterior cruciate ligament (ACL) sprain or tear from impact.

5. **Entire body:** Rolled off the hood of a 1969 Porsche 911 Targa. Moderate contusions (bruises) and abrasions (scrapes) likely.

6. **Abdomen (right side), anterior left femur:** Hit by shrapnel fragments from a close-range M67 grenade detonation. Deep lacerations with class I hemorrhage. If his femoral artery was hit, class IV hemorrhage possible (a fatal injury without emergency treatment).

7. **Thorax, arms:** Jumped shirtless through glass doors. Deep incisions on exposed areas with class II hemorrhage (involving 15 to 30 percent of total blood volume). Tendon and/or nerve damage probable.

8. **Right shoulder:** Shot with a Detonics Scoremaster pistol. The 11.5 mm caliber bullet grazed his shoulder. Superficial abrasion.

9. **Abdomen:** Slashed with a hunting knife. Deep incision with class I hemorrhage.

ADDITIONAL OBSERVATIONS: Patient appeared to take delight in the body count left in his wake, making wisecracks as he killed his enemies. Possible antisocial personality disorder (sociopathy).

PROGNOSIS: Any potential traumatic brain injury would likely require immediate neurosurgery. Without stopping off at an emergency room, the patient's vital signs would slowly deteriorate as the pressure mounted within his skull. Combined with the cumulative blood loss from his other injuries, Colonel Matrix's next stop would be the morgue.

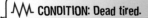 **CONDITION: Dead tired.**

BRUCE WAYNE

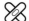

SCENE OF INCIDENT: *The Dark Knight Rises* (2012)

OCCUPATION: Batman

INCIDENT REPORT: Billionaire vigilante was critically injured saving Gotham City from a terrorist organization run by a masked revolutionary. Patient's back was broken, which led him to undergo a rather unconventional rehabilitation program.

INJURIES:

1. **Thorax:** Multiple brawls with terrorists. Patient's ceramic body plates and Kevlar bi-weave bodysuit provided protection against most of the usual injuries caused by hand-to-hand combat, but bruised or fractured ribs likely.

2. **Back:** Back snapped over the revolutionary's knee. Flexion and distraction of spinal column, causing spinal fracture dislocation of thoracic vertebrae (between T1 and T12)—i.e., a broken back. Dislocated vertebrae punctured skin; the bone was "punched" back into place by prison cellmate several days later. High risk of bacterial infection due to exposed bone.

3. **Head:** Hallucinations during recovery from broken back. Likely caused by fever due to infection.

4. **Neck:** Lost footing twice while rock climbing, falling approximately twenty to thirty feet each time. The patient's descent was stopped abruptly by a rope around his waist, which would result in a spinal fracture of the C1–C4 cervical vertebrae.

5. **Abdomen (right side):** After finally returning to Gotham, patient was stabbed by an ex-lover. Five-inch blade was buried to the hilt, resulting in a deep penetration wound. Class II hemorrhage; class III hemorrhage (involving moderate blood loss, or 30 to 40 percent of blood volume) possible, if blade penetrated the liver.

ADDITIONAL OBSERVATIONS: According to his primary-care physician, the patient had scar tissue on his kidneys and stage 4 osteoarthritis in his elbows, shoulders, and knees—all likely attributable to his extracurricular nighttime activities.

PROGNOSIS: Most injuries would heal within four to six weeks, although long-term antibiotic treatment might be required. Any spinal injury resulting in protruding vertebrae would cause permanent, irreversible damage to the spinal cord. With a fracture between the T1 and T12 vertebrae, Wayne would experience paralysis of the trunk and/or legs (paraplegia). Additionally, the second likely spinal fracture— occurring in the cervical section of vertebrae—would leave the patient quadriplegic (paralyzed from the neck down).

CONDITION: The Dark Knight would not rise.

SERGEANT JOHN SPARTAN

SCENE OF INCIDENT: *Demolition Man* (1993)

OCCUPATION: Police officer

INCIDENT REPORT: Los Angeles cop was awakened from suspended animation to track down his criminal arch-nemesis. Patient sustained multiple moderate injuries but fortunately survived a potentially fatal automobile accident thanks to the vehicle's futuristic safety features.

 INJURIES:

1. **Arms, face:** Jumped through a broken window. Later—thirty-six years later, in fact—the patient fell through a glass ceiling into a pile of well-placed burlap sacks. Would be cut extensively by glass shards. Class II hemorrhage and tendon and/or nerve damage probable.

2. **Face, arms:** Clashed with multiple adversaries. Superficial lacerations on face and arms. Head-butted in the face, which could result in a nasal fracture (broken nose).

3. **Face, arms:** Sprinted through flames. Probable first-degree burns (superficial burns with reddened skin).

4. **Ears:** Ran from a building as it was demolished by a C-4 explosion. Possible primary blast injury could include acoustic barotrauma (e.g., ear pain and temporary hearing loss due to overpressurization of the air from the blast wave).

5. **Entire body:** Cryogenically frozen from 1996 to 2032. Since placing a human being into cryopreservation requires the shutdown of all body systems, the patient would have been legally dead while frozen.

6. **Right hand:** After patient's revival, a GPS tracking chip was surgically implanted into the back of his hand.

7. **Thorax (left side):** Crashed a futuristic automobile into a cement fountain. Airbag-like foam deployment system allowed the patient to walk away with only a superficial laceration.

ADDITIONAL OBSERVATIONS: While a handful of people have been cryopreserved over the years, they haven't been thawed. The technology to resuscitate a frozen human being doesn't yet exist—and may never exist, according to scientists.

PROGNOSIS: Assuming that scientists work out a way to revive cryopreserved individuals in the future, Sergeant Spartan would heal from most of his other injuries within six to eight weeks. Tendon and nerve damage, however, could result in permanent disability—although if the medical community has figured out how to revive cryopreserved patients, restoring full movement and feeling to affected areas shouldn't be a problem.

CONDITION: Full recovery expected. Pretty good for someone who was technically dead for over three decades.

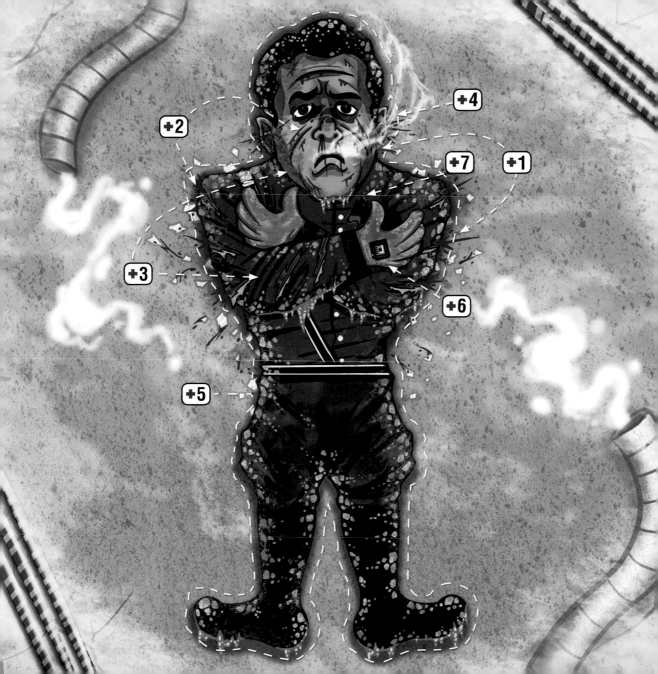

El MARIACHI

SCENE OF INCIDENT: *Desperado* (1995)

OCCUPATION: Mariachi (retired)

INCIDENT REPORT: Patient tracked and killed a band of drug-dealing criminals responsible for his girlfriend's death. Despite being severely wounded on multiple occasions, patient still found time to make love to the most beautiful bookseller in Mexico.

 INJURIES:

1. Right shoulder: Shot with a Ruger KP90 pistol. Class I hemorrhage (class II if bullet damaged his brachial artery). Embedded 11.5 mm caliber bullet removed by a bookseller, who cauterized the wound with a cigarette. Cauterization is usually a last-ditch effort to stop bleeding—even if successful, the burnt tissue greatly increases the chances of a bacterial infection setting in.

2. Left shoulder blade, left biceps, right forearm: Struck by three knives thrown by an assassin, each resulting in a deep penetration wound of half an inch or more. Class II hemorrhage, with hypovolemic shock due to lack of immediate medical attention. Muscle, tendon, and/or nerve damage probable.

3. Right shoulder, back: Leapt from a building and landed on his back on a neighboring rooftop a full story down. Would suffer—at minimum—a dislocated shoulder. More likely, the patient would fracture multiple vertebrae.

ADDITIONAL OBSERVATIONS: The patient had lingering tendon and nerve damage to his left hand from being shot during an earlier incident, which severely curtailed his ability to play guitar. His ability to pull triggers, however, was obviously unaffected.

PROGNOSIS: Shock from cumulative blood loss would be survivable, but would require emergency oxygen and fluid replacement. Most injuries would heal within six to eight weeks (provided, of course, that his spinal cord was not nicked or severed by any fractured vertebrae). Muscle, tendon, and/or nerve trauma from the knife wounds, however, could permanently affect movement and feeling in El Mariachi's upper extremities—particularly in his all-important trigger fingers.

CONDITION: Herido, pero vivo.

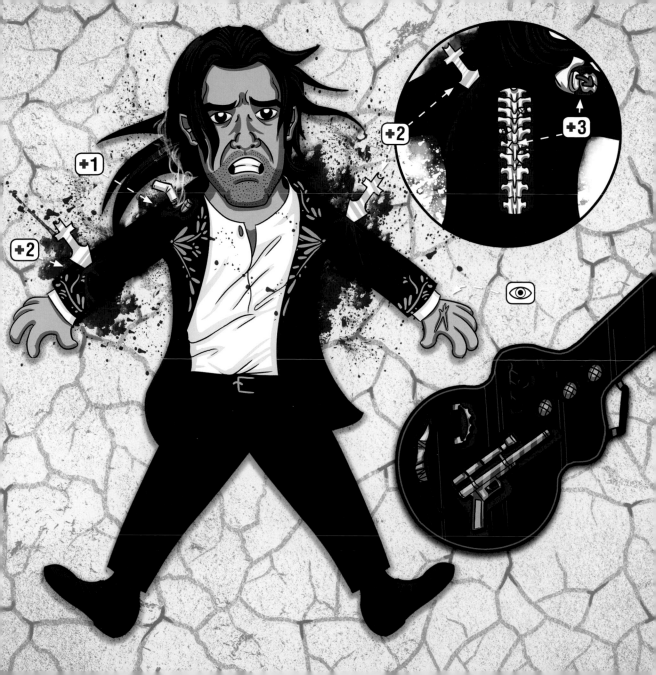

DETECTIVE JOHN McCLANE

SCENE OF INCIDENT: *Die Hard* (1988)

OCCUPATION: Police officer

INCIDENT REPORT: Off-duty New York City cop was involved in a terrorist incident at Nakatomi Plaza. Patient engaged suspects in hand-to-hand combat and exchanged gunfire with them before leaping off a rooftop with a fire hose around his waist.

INJURIES:

1. Entire body: Multiple fistfights with Eurotrash terrorists. Thrown into drywall. Superficial lacerations and contusions on hands, elbows, and forearms. Deep laceration on patient's eyebrow with class I hemorrhage. If untreated, bleeding could temporarily obscure vision.

2. Back: Tumbled down a flight of stairs. Simultaneous flexion and distraction of the spinal column would cause spinal fracture of the T12–L2 vertebrae (broken back).

3. Feet, thorax, arms: Walked barefoot on broken glass. Later, crashed shirtless through a window and was dragged by a terrorist across glass shards. Numerous deep incisions. Cumulative class II hemorrhage.

4. Head: Kicked repeatedly in the head. Epistaxis. Nasal fracture possible. Mild concussion likely.

5. Right shoulder: Shot with a Beretta 92F semiautomatic pistol (9 mm caliber bullet). Penetrating trauma with no exit wound. Class I hemorrhage.

6. Neck: Jumped off the rooftop of a high-rise building with a fire hose around his waist. Unfortunately for the patient, fire hoses lack the elasticity of bungee cords. On reaching the end of the length of hose, his body would have come to an abrupt stop. Hyperflexion (forward motion) of the neck would result in cervical fracture of C5–C7 vertebrae (broken neck).

ADDITIONAL OBSERVATIONS: Ingested "thousand-year-old" Twinkie of indeterminate origin. If it had gone bad, the patient would experience symptoms of food poisoning (nausea, vomiting, diarrhea, abdominal pain, and fever) within a few hours.

PROGNOSIS: Provided Detective McClane received prompt medical attention for his cumulative blood loss, most of his injuries would heal within four to six weeks. Combined injuries to the patient's spinal column, however, would likely leave him paralyzed from the neck down (quadriplegic).

CONDITION: Unable to walk off into the sunset with Grace Kelly.

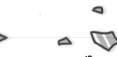

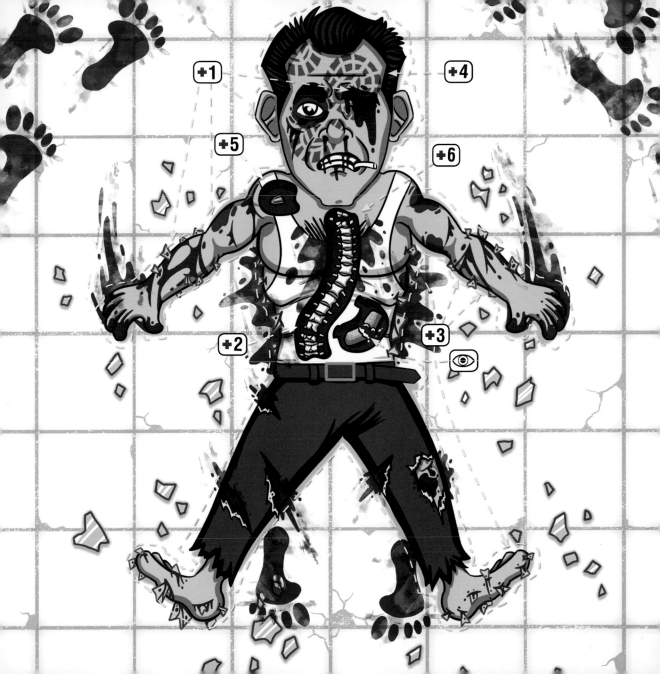

LEE

SCENE OF INCIDENT: *Enter the Dragon* (1973)

OCCUPATION: Shaolin monk

INCIDENT REPORT: Shaolin martial artist chopped, struck, blocked, and kicked his way through a martial arts tournament on an isolated Pacific island. Patient sustained multiple moderate injuries during his showdown with the tournament's host, a disgraced monk heading up a criminal empire.

INJURIES:

1. Hands, feet: Engaged multiple adversaries in hand-to-hand combat. Because his training emphasized readiness and adaptability over any particular style, the patient utilized fighting techniques from multiple disciplines to keep his opponents on their toes—and to avoid being struck. Contusions still possible on feet and the knuckles of both hands.

2. Right cheek: Slashed by a triple-pronged steel bear claw wielded by the tournament's host. Superficial incisions.

3. Left cheek, abdomen, thorax (right side), back (upper left side): Cut several times with a knife hand (a weapon with four protruding blades). Deep incisions with class I hemorrhage.

4. Hands: Punched multiple mirrors with bare hands while fighting the tournament's host. No matter how good his technique, the razor-sharp edges of the glass shards would still cause deep incisions. Class II hemorrhage and tendon and/or nerve damage probable.

ADDITIONAL OBSERVATIONS: Handled a Chinese cobra without precautions such as goggles and tongs. Had the patient been bitten, he would have sustained localized injuries (swelling, blisters, necrosis), possible flulike symptoms (fever, aches), and possibly death. Cobra poisoning is treatable with antivenom, though its availability on the remote island would undoubtedly be limited.

PROGNOSIS: The cumulative blood loss would likely send the patient into shock, requiring emergency oxygen and fluid replacement. Most injuries would heal within three to four weeks. Tendon and nerve damage, however, could take six to eight weeks to heal, and could result in loss of feeling or full movement in fingers.

CONDITION: Partial recovery expected, although Lee's flying fists of fury may be permanently grounded.

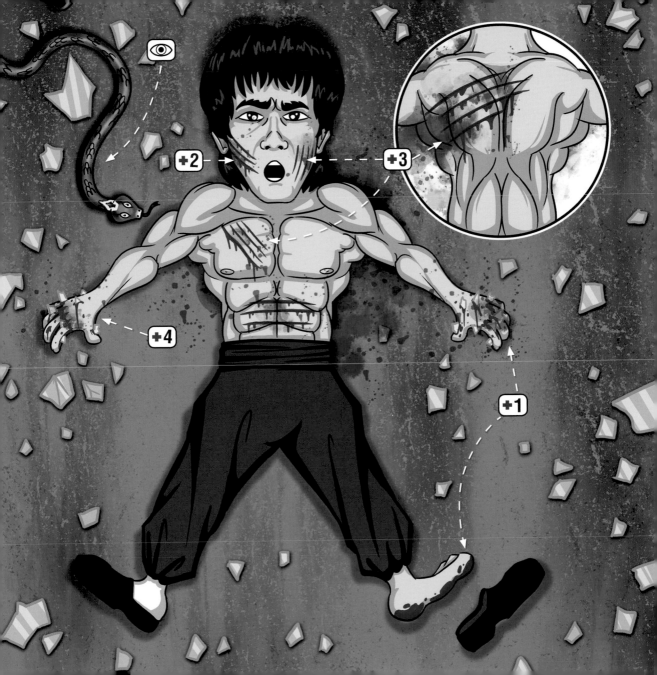

ROBERT McCALL

 SCENE OF INCIDENT: *The Equalizer* (2014)

OCCUPATION: Home Mart associate

INCIDENT REPORT: Retired CIA operative working at a home improvement superstore inadvertently started a one-man gang war with a group of Russian gangsters. Even in retirement, patient was an efficient killing machine, sustaining surprisingly few injuries for someone with an AARP card.

INJURIES:

1. Hands: Multiple one-sided beatdowns of Russian gangsters and corrupt cops. Bruised knuckles. Patient's age group is at high risk for osteoporosis (a common disease that weakens bones), so fractured knuckles and wrists are also a real possibility.

2. Anterior right femur: Shot with an IMI Micro Uzi submachine gun. Grazed by a 9 mm caliber bullet. Class I hemorrhage.

3. Ears, entire body: Casually strolled away from exploding gas tanks as shrapnel fragments blew past him. Supersonic blast wave would have caused primary blast injury (acoustic barotrauma) and secondary blast injury (penetrating trauma from flying objects).

4. Head, hands: Rolled around in broken glass while wrestling a Russian thug. Glass shards would cause deep incisions on exposed areas (shaved scalp, bare hands), resulting in class II hemorrhage.

ADDITIONAL OBSERVATIONS: The patient poured hydrogen peroxide and boiling pure clover honey on his gunshot wound to disinfect it. Unfortunately, clover honey's worth as a topical anti-infective has never been scientifically proven. Additionally, studies have shown that hydrogen peroxide is about as effective at staving off infection as soap and water—and may even damage healthy tissue.

PROGNOSIS: McCall would require immediate oxygen and fluids to survive the hypovolemic shock stemming from his cumulative blood loss. His injuries would heal within six to eight weeks (a noticeably longer recovery timeframe than for younger patients with similar trauma). Lastly, the patient could require long-term antibiotic treatment for bacterial infection stemming from his improperly treated gunshot wound.

CONDITION: Full recovery expected—this time. He should probably go back into retirement, but you gotta be who you are in this world.

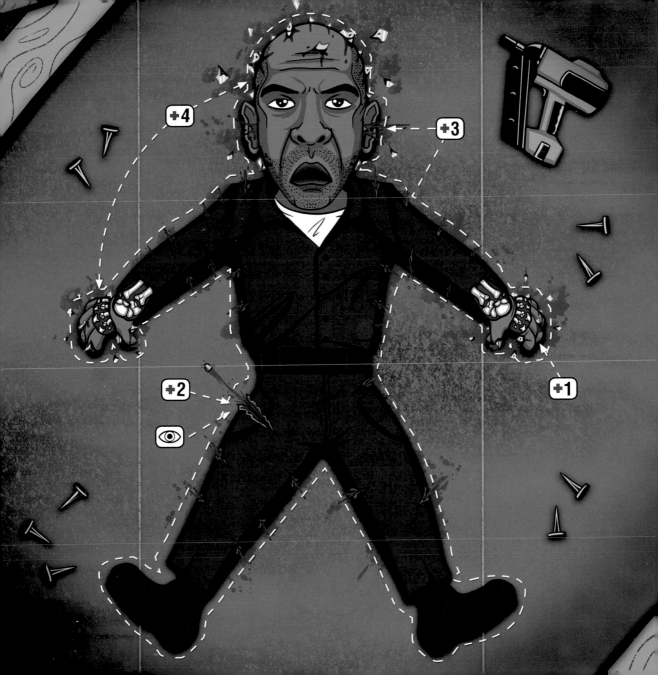

ASH WILLIAMS

SCENE OF INCIDENT: *Evil Dead II* (1987)

OCCUPATION: S-Mart clerk

INCIDENT REPORT: Retail clerk accidentally unleashed powerful demonic forces that critically wounded him. When an evil spirit possessed his right hand, the patient amputated the infected extremity and replaced it with a chainsaw.

INJURIES:

1. Head, neck: Slammed against a tree. Severe concussion with loss of consciousness. Probable neck sprain.

2. Face, back: Crashed an Oldsmobile head-on into a tree and was thrown through the windshield. Superficial lacerations on face. Fracture of thoracic and lumbar spine (broken back) likely.

3. Right hand: Hand bitten by his girlfriend's possessed corpse. Puncture wounds with superficial bleeding. Human bites carry a high risk of bacterial infection, but that issue soon became the least of the patient's worries: A demonic spirit entered his body through the wounds, possessing his hand.

4. Head, entire body: Assaulted by multiple paranormal entities (including his own hand, which smashed dishes over his head). Numerous contusions and superficial lacerations.

5. Right wrist: Stabbed steak knife through his possessed hand before amputating it with a chainsaw. Class II hemorrhage. To stem the bleeding, the patient created a tourniquet using duct tape and rags—an adequate if wildly unsanitary measure.

6. Face: Punched and kicked in the face—by a person this time, not a demon. Severe concussion with loss of consciousness. Superficial laceration on scalp.

ADDITIONAL OBSERVATIONS: Patient strapped a chainsaw onto his residual limb (stump). While technically feasible, the extreme pain caused by the chainsaw vibrating on the fresh wound would likely cause loss of consciousness.

PROGNOSIS: Despite the makeshift tourniquet, the patient would still be at risk for hypovolemic shock due to the blood loss already suffered. Immediate fluid replacement would be necessary—no time for Williams to strap on a chainsaw, in other words. Assuming he didn't die of shock, the rest of his injuries would heal within two to three months. His residual limb would have to be watched for signs of infection, as the jagged nature of chainsaw lacerations provides ample opportunity for bacteria growth.

CONDITION: Besides the amputation, he would be groovy.

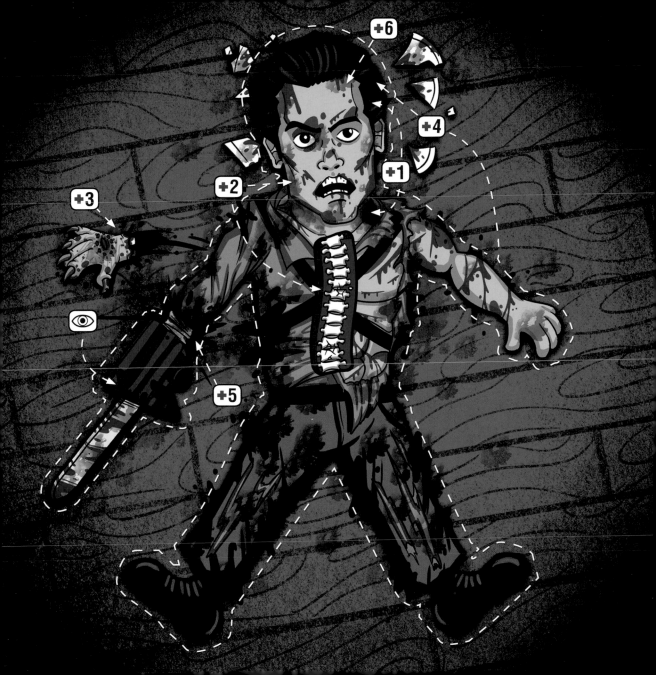

SEAN ARCHER

SCENE OF INCIDENT: *Face/Off* (1997)

OCCUPATION: FBI special agent

INCIDENT REPORT: FBI agent "traded faces" with a criminal mastermind to gain information on a planned terrorist attack. Patient sustained multiple critical injuries, beyond the obvious risks of a full facial transplant.

INJURIES:

1. Back (right side), thorax: Shot in the back with a Remington 700 PSS rifle (7.8 mm caliber bullet). Exit wound on chest (thorax). Class I hemorrhage; possibility of additional blood loss if bullet perforated his subclavian artery (a major artery below the clavicle). Likely collapsed lung (pneumothorax).

2. Abdomen: Abdominoplasty. Postsurgical pain and swelling likely.

3. Face: Face transplant (later reversed). Operative and postoperative risks would include inflamed and destroyed tissue, bacterial infection, severe hemorrhage, and blood clots.

4. Neck: Microchip implanted in patient's larynx to modify his voice.

5. Face, abdomen (left side): Multiple fistfights, including one in which the patient was cut with metal debris. Superficial lacerations on left eyebrow and cheek. Epistaxis. Superficial laceration on abdomen. Potential damage to still-healing facial tissue.

6. Face, hands, feet: Shoes set on fire. Later, crashed a boat through another boat, which ignited in flames. Possible first-degree burns on feet and exposed areas.

7. Back: Jumped approximately two hundred feet into the ocean from an "inescapable" prison. Patient would have been traveling at sixty-five to seventy-five mph when he hit the water, likely fracturing his spinal column (T12–L2 vertebrae).

8. Abdomen (left side): Shot with a SIG Sauer P226 pistol (9 mm caliber bullet). Class I hemorrhage. Any perforation of internal organs would result in additional blood loss and increased risk of infection.

ADDITIONAL OBSERVATIONS: While the technology exists to perform a full facial transplant, the procedure is far from perfected. Even with immunosuppressant drugs to prevent the immune system from attacking transplanted tissue, tissue rejection is common.

PROGNOSIS: Healing times for successful facial transplants are measured in years, rather than the scant couple of days the patient had to recover. If Archer somehow healed in time to infiltrate the prison, he would have drowned after breaking his back during his escape attempt.

CONDITION: Deceased—although the criminal he swapped faces with would keep his good name alive.

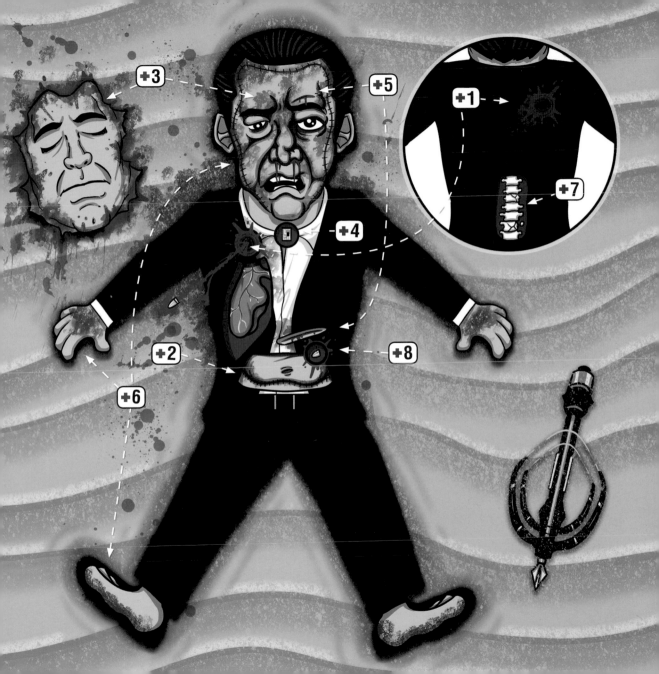

JACK

SCENE OF INCIDENT: *Fight Club* (1999)

OCCUPATION: Automotive recall specialist

INCIDENT REPORT: Insomniac office worker founded a chain of underground bare-knuckle "fight clubs." Patient's most dangerous conflicts were with his own split personality, however, resulting in several critical injuries.

 INJURIES:

1. Head, hands: Numerous fistfights, including several with himself. Deep laceration on forehead with class I hemorrhage. Epistaxis. Avulsed (knocked out) tooth. Bilateral periorbital hematomas (black eyes). Bruised and/or dislocated knuckles possible.

2. Right hand: Burned with powdered lye (sodium hydroxide) mixed with saliva. Second-degree burn (partial thickness, with severe blistering, peeling, and swelling). The lye was "neutralized" with vinegar, which would actually cause the chemical reaction to burn more.

3. Face, head, back: Patient flung himself backward through a glass table. Later, patient threw himself through a parking garage window and slammed his own face into a van's sideview mirror. Glass shards would cause deep incisions on contact areas. Cumulative class II hemorrhage.

4. Head, neck: Auto collision into rear bumper of a parked car, followed by rollover crash into a ditch. Possible cervical fracture of C1–C4 vertebrae (broken neck). Possible traumatic brain injury.

5. Right ankle, back: Tumbled down three flights of stairs. Fractured ankle. Spinal fracture of T12–L2 vertebrae likely.

6. Left cheek: Shot self in mouth with a Smith & Wesson 4506 pistol (11.5 mm caliber bullet). Exit wound in cheek with class I hemorrhage. Recoil action resulted in avulsed back molar and probable fractured jaw. Ruptured eardrum likely from proximity to gunshot.

ADDITIONAL OBSERVATIONS: Although the "split personality" may be a hallucination due to patient's previously diagnosed sleep deprivation, evaluation for dissociative identity disorder is strongly recommended.

PROGNOSIS: While most of the patient's bareknuckle-boxing injuries would heal in a matter of weeks on their own, any brain injury from the car wreck would likely require immediate neurosurgery. Further down the line, reconstructive surgery would be required to repair the gaping gunshot wound in his cheek. Even then, his return to fighting shape would still be doubtful: The multiple spinal fractures would likely result in paralysis from the neck down.

CONDITION: Quadriplegic. On the bright side, it's only after we've lost everything that we're free to do anything.

26

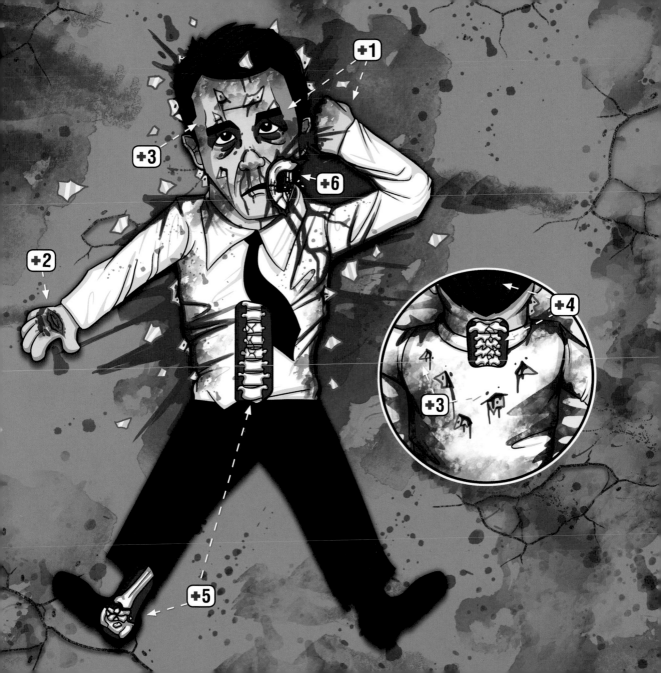

DOMINIC TORETTO

SCENE OF INCIDENT: *Furious 7* (2015)

OCCUPATION: Auto mechanic

INCIDENT REPORT: Street-racing gearhead and his fast and furious family were stalked by an international terrorist with a grudge. Patient went on the offensive, totaling several cars—and himself—in the process.

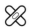

INJURIES:

1. Ears, entire body: Knocked to the sidewalk by a C-4 explosion. Probable primary blast injury (acoustic barotrauma) and tertiary blast injury (contusions from hitting the ground).

2. Thorax, abdomen: Smashed a Plymouth Road Runner head-on into a modified Maserati Ghibli. Later, plowed head-on into an Aston Martin with a Dodge Charger. Though an airbag was deployed the first time, injuries from either collision would include blunt trauma to the chest and fatal compression of intra-abdominal organs.

3. Face, hands, thorax: Scuffled with soldiers. Later, engaged in a street fight. Multiple body and face blows with tire irons and wrenches. Abrasion (scrape) on left cheek. Fractured jaw and/or ribs likely.

4. Neck, head: Rolled a structurally reinforced Dodge Charger down a steep rock face, totaling the vehicle. Probable cervical fracture of C1–C4 vertebrae (broken neck) and traumatic brain injury (such as skull fracture and intracranial hemorrhage).

5. Right hand: Wounded by shrapnel from an M26 grenade. Deep laceration between thumb and forefinger with class I hemorrhage.

6. Heart, lungs: Ramped his Charger off the third floor of a parking garage, crash-landing on unforgiving pavement and crushing his torso. Cardiac and respiratory arrest from hypovolemic shock caused by internal bleeding. Cardiopulmonary resuscitation (CPR) unsuccessful. However, the sound of his wife's voice miraculously brought him back to life.

ADDITIONAL OBSERVATIONS: Jumped a multi-million-dollar Lykan HyperSport from the forty-fifth floor of an Abu Dhabi skyscraper into a neighboring tower. Repeated the trick, landing inside a third tower. Unfortunately for the patient, physics says the car would take a fatal nosedive upon exiting the first building.

PROGNOSIS: Sadly for Toretto, spontaneous recovery from cardiac and respiratory arrest at the sound of a loved one's voice is an impossibility—not that it matters. In all likelihood, he would have been dead many times over by that point. If the head-on collisions didn't kill him, the jump between buildings would have.

CONDITION: Beyond repair.

KATNISS EVERDEEN

SCENE OF INCIDENT: *The Hunger Games: Catching Fire* (2013)

OCCUPATION: Hunger Games champion

INCIDENT REPORT: Former Hunger Games winner was forced by the tyrannical Capitol to return to the Games to battle other champions to the death. Patient was critically injured during a daring escape orchestrated by anti-Capitol rebels.

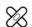 **INJURIES:**

1. Left cheek, back: Punched in the face and flogged on the back with a cat-o'-nine-tails. Superficial laceration on cheek. Leather jacket protected the patient's back, but contusions still possible.

2. Entire body: Dehydrated from excessive perspiration (diaphoresis) and lack of fluids inside the Arena. Muscle weakness. Would also experience headaches, dizziness, and decreased urination.

3. Face, hands: First-degree chemical burns from poison fog.

4. Lungs: Submerged underwater by a mutant monkey that was attempting to drown her. Later, fell into turbulent waters. Possible inhalation of water into airway from one or both incidents, which could lead to difficulty breathing and eventual asphyxiation (death from lack of oxygen).

5. Head: Struck with a metal spool of wire in the back of the head. Moderate concussion. Superficial laceration on scalp possible.

6. Right forearm: Tracking beacon cut out of patient's arm using an unsterilized knife. Deep incision with class I hemorrhage. Infection likely.

7. Hands, feet, head: Struck by lightning, which entered through her feet and exited through her hands (a so-called vertical pathway). Severe concussion with loss of consciousness. Epistaxis. Would have second-degree electrical burns at current's entry and exit points.

ADDITIONAL OBSERVATIONS: Post-traumatic stress disorder (PTSD) from first Hunger Games experience, wherein she was forced to murder opponents. PTSD symptoms experienced by the patient included hallucinations, sleep disturbances, diminished interest in once-pleasurable activities, and aggression.

PROGNOSIS: After receiving first aid for her multiple burns and blood loss, Everdeen would need to be monitored for signs of "dry drowning" (coughing, chest pain, difficulty breathing). Repeated concussions in such a short succession could lead to postconcussion syndrome (disorientation, irritation, headaches), which could linger for weeks or months. PTSD symptoms would likely worsen following her return to the Games.

CONDITION: Full physical recovery expected. As for a full psychological recovery, however, the odds aren't in Everdeen's favor.

Dr. INDIANA JONES

SCENE OF INCIDENT: *Indiana Jones and the Temple of Doom* (1984)

OCCUPATION: Archaeologist

INCIDENT REPORT: Professor of archaeology entered an Indian temple in search of fortune and glory, but instead found a human-sacrificing cult. Patient was tortured, hypnotized, and used as a metaphysical pincushion before making his escape.

INJURIES:

1. Entire body: Ingested a lethal poison (likely a plant-based toxin). Initial symptoms included rapid heart rate and excess sweating. Antidote orally administered to neutralize the poison.

2. Face, hands, thorax (right side): Tussled with multiple adversaries. Superficial laceration on right temple. Epistaxis and lacerated (split) bottom lip. Bruised knuckles. Superficial incision to patient's chest from a knife blade.

3. Entire body: Exited an airborne plane on an inflated life raft, which he rode over five hundred feet to the ground. However, physics says the raft would have dumped the patient overboard. Upon hitting the earth at terminal velocity (roughly 124 mph), his internal organs and bones would have been pulverized.

4. Neck: Choked by an assassin's rope. Temporary impairment of consciousness due to mild hypoxia. Choking would also result in temporary gray-blue skin (cyanosis) and contusions around the patient's neck.

5. Back: Flogged multiple times with a bullwhip, which split open the patient's shirt. Multiple deep lacerations with class I hemorrhage.

6. Head: Hypnotized into doing the cult's bidding after drinking the "Blood of Kali," a liquid spiked with an unknown drug that made the patient open to suggestion.

7. Abdomen (right side): Hypnotic trance was broken when the patient was burned by a torch. First-degree burn.

8. Entire body: Temporarily paralyzed by pins stuck into a voodoo doll.

9. Feet: Stopped an out-of-control mining cart's wheels with his shoes, which smoked from the friction. Probable first-degree burns.

ADDITIONAL OBSERVATIONS: The patient's fall from a sixth-story window was broken by a series of awnings, which slowed his velocity—a plausible (if highly unusual) way to survive a sixty-foot drop.

PROGNOSIS: Most injuries would heal within six to eight weeks, though it would be a moot point: Falling from the life raft would have turned the patient into a bloody bag of bone fragments and ruptured organs. Instead of fearing snakes, perhaps Dr. Jones should have worried more about heights.

CONDITION: Killed while chasing fortune and glory.

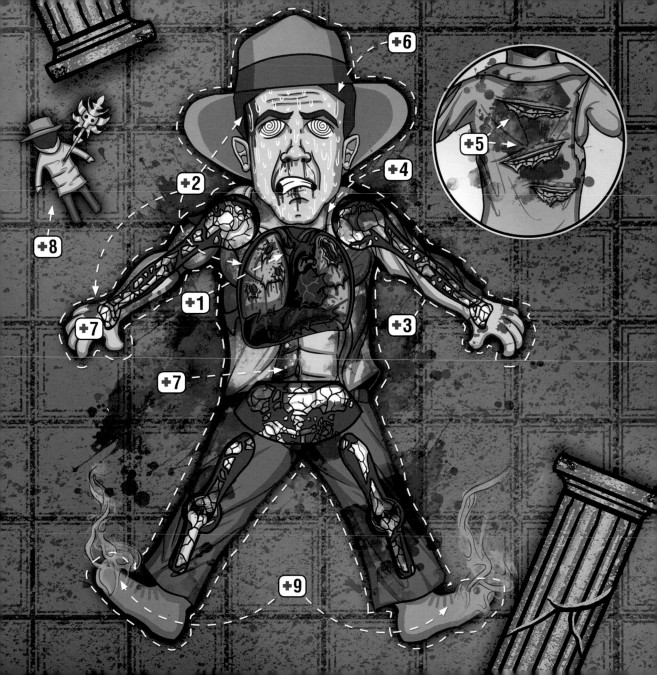

TONY STARK

 SCENE OF INCIDENT: *Iron Man* (2008)
OCCUPATION: Stark Industries CEO
INCIDENT REPORT: Billionaire arms dealer was kidnapped by terrorists after being critically injured by an improvised explosive device (IED). Patient escaped by engineering a mechanical suit of armor powered by a fusion-fueled "arc reactor"—a device that kept him alive.

 INJURIES:

1. Face, ears, thorax: Blown off his feet by an IED detonation. Contusions and abrasions on face. Secondary blast injury (shrapnel fragments penetrated his thoracic cavity). Class III hemorrhage with hypovolemic shock. Primary blast injury (acoustic barotrauma) probable.

2. Thorax: Electromagnet implanted in chest to keep the embedded shrapnel from migrating into his heart. Inorganic materials like the magnet—or, later, the arc reactor that was added to power the magnet—don't carry the same risks of rejection that come with tissue transplants, although localized pain and swelling would be likely.

3. Lungs: Subjected to simulated drowning. Possible inhalation of water into airway.

4. Right shoulder, back: Crash-landed a prototype suit into a sandbar from hundreds of feet in the air. Probable torn shoulder labrum. Fracture of thoracic and lumbar spine (broken back) likely.

5. Heart: Sudden cardiac arrest during removal of the original arc reactor from his chest. Insertion of a new arc reactor defibrillated his heart, resetting it to its normal sinus rhythm.

6. Left shoulder, neck: Racked up several injuries while testing the suit's thrusters and flight stabilizer, including a dislocated shoulder and possible neck strain (whiplash).

7. Ears: Temporarily paralyzed by a sonic taser, a device that overloads the central nervous system with a targeted ultra-high frequency blast.

8. Head: Knocked unconscious by shock waves from a close-range explosion. Severe concussion.

ADDITIONAL OBSERVATIONS: Slammed around during a slugfest with a similarly armored adversary on the streets of Los Angeles. While the patient should have suffered mortal injuries similar to those seen in head-on automobile collisions, he was relatively unscathed due to his suit's ability to absorb and redistribute kinetic energy.

PROGNOSIS: Stark survived his IED-related injuries thanks to a doctor who realized a high-powered magnet was a viable alternative to invasive surgery. As long as his spinal cord wasn't damaged crashing the prototype suit, most of his other injuries would heal within two to three months.

CONDITION: Full recovery expected, although he'd be in pain for a while. Nothing a little scotch couldn't fix.

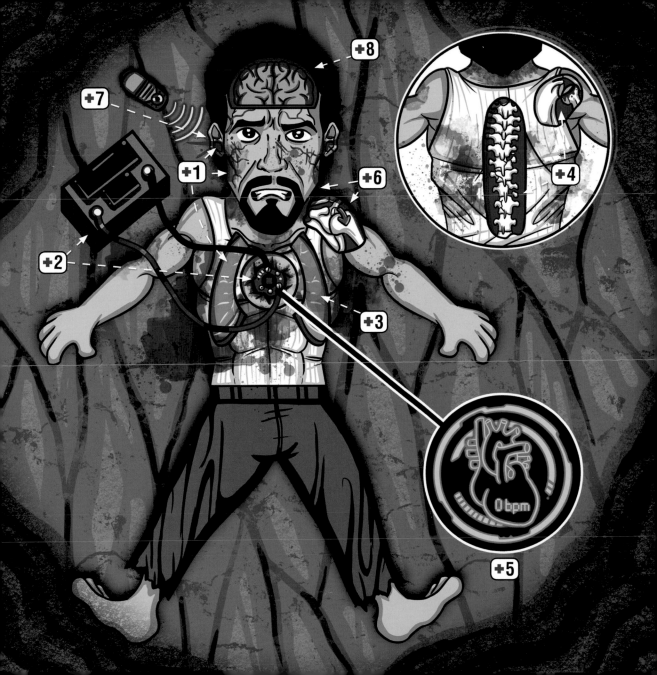

BEATRIX KIDDO

SCENE OF INCIDENT: *Kill Bill: Vol. I* (2003)

OCCUPATION: Assassin (retired)

INCIDENT REPORT: Former assassin was shot in the head by her ex-boss (and ex-lover) Bill. After four years in a coma, patient embarked on a quest for revenge against Bill and his squad of assassins, sustaining numerous minor injuries from hand-to-hand combat and swordfights.

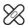 **INJURIES:**

1. Head: Shot with an EMF Hartford Pinkerton revolver (11.48 mm caliber bullet) in the left temple. Skull fracture and intracranial hematoma. Class II hemorrhage. Hypovolemic shock, with loss of consciousness. Emergency craniotomy to relieve pressure and clear bullet fragments. Cranial damage repaired with titanium plate.

2. Left hand, face: Martial arts fight with metal, wooden, and ceramic household objects used as weapons. Deep incisions on face and hand from mirror shards and broken ceramic dishes. Class I hemorrhage. Tendon and/or nerve damage possible.

3. Right shoulder: Cut in the shoulder by the saw blade of a single-headed meteor hammer (a Chinese weapon similar to a ball-and-chain flail or mace). Deep incision with class I hemorrhage.

4. Skin, neck: Briefly choked with the meteor hammer's chain, resulting in temporary cyanosis. Possible contusions around neck.

5. Thorax: Hit twice with the sphere (head) of the meteor hammer, then kicked in the chest and slammed through a wooden table. Hemoptysis (coughing up blood from respiratory tract). Fractured ribs likely.

6. Abdomen, back: While slicing her way through eighty-eight sword-wielding martial artists, patient was cut on her abdomen and back; thankfully, neither incision penetrated her abdominal cavity. Class I hemorrhage.

ADDITIONAL OBSERVATIONS: Immediately after emerging from her coma, patient somehow had the upper body strength to crawl. In reality, her muscles would have atrophied from four years in a vegetative state, leaving her unable to even sit up.

PROGNOSIS: While nine out of ten gunshot victims with traumatic brain injury don't survive, Kiddo was clearly one of the lucky ones. Aside from some loss of feeling or movement in the fingers of her left hand because of tendon and/or nerve damage from postcoma penetrating trauma, the patient's injuries would heal within a couple of months.

CONDITION: Partial recovery expected. Look out, Bill.

SERGEANT MARTIN RIGGS

 SCENE OF INCIDENT: *Lethal Weapon* (1987)

OCCUPATION: Police officer

INCIDENT REPORT: Suicidal narcotics detective dismantled a drug-trafficking ring. Despite patient's reckless behavior—leaping off buildings, using his skull as a weapon, putting a gun to his own head—he sustained only moderate injuries.

INJURIES:

1. Head: Repeated head-butting of suspects. Superficial laceration on forehead. Even with a well-executed head-butt—where the attacker's forehead connects with the recipient's nose—it's possible for the assailant to knock him- or herself out. Therefore, multiple mild concussions probable.

2. Left wrist: Leapt six stories (sixty feet) onto an inflatable safety bag while handcuffed to a suicidal jumper. Possible fractured wrist from the handcuffs due to unnatural contortion.

3. Ears, left shoulder, back: Thrown to the ground by an exploding house. Probable primary blast injury (acoustic barotrauma) and tertiary blast injury (contusions on shoulder from hitting the ground). Possible first-degree burns on back from flaming debris that ignited the patient's coat on fire.

4. Thorax, head: Shot with a Remington 870 twelve-gauge shotgun and thrown backward through a picture window by force of the buckshot. Though protected from penetrating trauma by a ballistic (bulletproof) vest, blunt trauma (fractured ribs) possible. Mild concussion.

5. Torso: Hung shirtless by wrists and electrocuted with car battery jumper cables. Second-degree burns at entry and exit points of electrical current, with possible internal injury.

6. Face, left forearm, hands: Multiple bare-knuckle brawls. Epistaxis and superficial laceration on bridge of nose. Broken forearm. Bruised and/or dislocated knuckles likely.

7. Entire body: Hit by a taxi skidding to a stop. Rolled onto the hood, broke the windshield, and fell onto the street. Moderate contusions and abrasions likely.

ADDITIONAL OBSERVATIONS: Patient's active suicidal ideations and impulsive behavior are symptomatic of chronic traumatic encephalopathy (CTE), a degenerative disease caused by repeated concussive hits. Unfortunately, diagnosis of CTE can only be made during a postmortem examination.

PROGNOSIS: Barring the possibility of damage to internal vessels and organs from being electrocuted, Sergeant Riggs didn't sustain any lethal injuries. Cumulative trauma would heal within four to six weeks. CTE symptoms would require long-term psychiatric treatment. Psychological fitness-for-duty (FFD) evaluation recommended.

CONDITION: Full physical recovery expected, but he could end up drawing a "psycho pension" sooner rather than later.

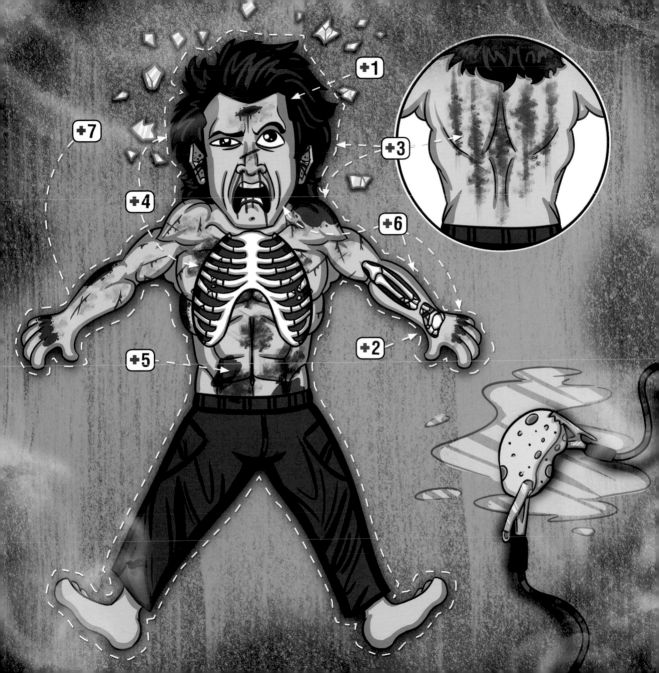

IMPERATOR FURIOSA

SCENE OF INCIDENT: *Mad Max: Fury Road* (2015)

OCCUPATION: War Boys soldier

INCIDENT REPORT: Deserting soldier fled across a postapocalyptic wasteland in search of freedom from deranged warlord. Patient received a (possibly) life-saving blood transfusion after suffering mortal injuries at the hands of one of the warlord's soldiers.

 INJURIES:

1. Lungs: Drove through a sandstorm. Shielded eyes with goggles. Covered nose and mouth with cloth, although this would only provide partial protection. Shortness of breath and reflex coughing possible.

2. Head: Hand-to-hand combat with multiple adversaries. Blows to the head from head-butts and being bashed against metal surfaces. Epistaxis. Superficial laceration on bottom lip. Forehead contusion. Unilateral periorbital hematoma (black eye). Possible mild concussion.

3. Eyes: Vision impaired by a smoke bomb. Eye irritation and redness likely.

4. Anterior thoracoabdominal region (right side): Stabbed with a metal shiv. Deep penetration wound with class II hemorrhage. Bilateral hemopneumothorax (collapsed lungs) due to excess blood and air in the pleural space (thoracic cavity).

5. Neck: Minor fender-benders with war rigs. Neck strain (whiplash) probable.

6. Anterior thoracoabdominal region (left side): Knife slipped into patient's side to release excess blood and air from the pleural space and relieve pressure on her collapsed lungs. Deep penetration wound. Class III hemorrhage from cumulative trauma, resulting in hypovolemic shock and unconsciousness.

ADDITIONAL OBSERVATIONS: Received a direct whole-blood transfusion from a donor with type O negative blood. Type O negative donors are often referred to as "universal blood donors" for their blood's "universal" compatibility with recipients. However, the "universal" tag only applies to donations of one component of blood—red blood cells—and not whole blood. When it comes to whole-blood transfusions, both donors and recipients should have the same blood type to avoid complications.

PROGNOSIS: The good news is there's an over 40 percent chance Imperator Furiosa had type O blood, meaning her blood would most likely be compatible with her donor's. The bad news is there's an even greater chance she *didn't*, meaning she would be at risk of experiencing a fatal, acute hemolytic transfusion reaction. Regardless, the patient would likely die soon anyway: In a postapocalyptic world without antibiotics, either one of her stab wounds could lead to a fatal infection.

CONDITION: On the road to Valhalla.

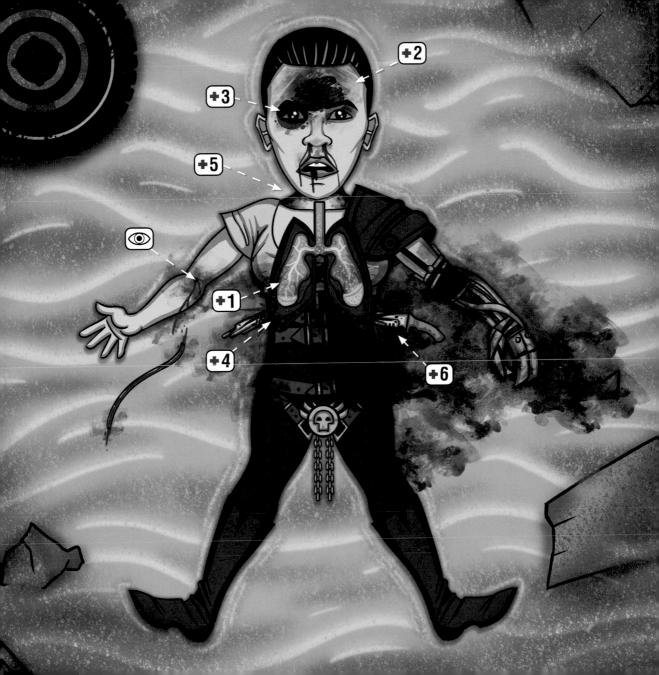

ETHAN HUNT

SCENE OF INCIDENT: *Mission: Impossible III* (2006)
OCCUPATION: IMF agent
INCIDENT REPORT: Secret agent rescued his wife from a sadistic illegal-arms dealer. Patient survived several impossibly dangerous situations, including self-induced cardiac arrest.

 INJURIES:

1. Neck, head: Survived several close-range missile strikes, including one that upended patient's SUV and one that threw him against the side of a car. Possible tertiary blast injury such as cervical fracture of C1–C4 vertebrae (broken neck) and traumatic brain injury.

2. Face, hands: Multiple fistfights. Contusions on face. Bruised or fractured knuckles possible.

3. Thorax: Leapt off a high-rise building with a climbing rope attached to a torso harness. Bruised or fractured ribs possible from the harness.

4. Face: Jumped through two windows. Most of the patient's body was protected with a Kevlar jacket, but his face was exposed to sharp glass shards. Deep incisions on right cheek and bridge of nose. Class I hemorrhage. Nerve damage possible.

5. Head, face: Nitroglycerin microexplosive injected into cranial cavity via nostril. Epistaxis. Postsurgical swelling of nasal passage likely.

6. Thorax, upper extremities: Thrown through multiple windows and dragged through shattered glass during a fistfight. Deep incisions on upper body. Probable class II hemorrhage. Damage to tendons, nerves, and/or muscle tissue likely.

7. Hands, heart: To short the microexplosive in his brain, patient electrocuted himself by gripping both ends of an uninsulated electrical wire. An AC current passed through his body along a transthoracic (hand-to-hand) pathway, causing ventricular fibrillation (irregular electrical activity in the heart) and cardiac arrest. Revived after 150 seconds with CPR. Second-degree burns on palms likely.

ADDITIONAL OBSERVATIONS: Opened the emergency exit on a plane at cruising altitude. Patient should have lost consciousness due to insufficient oxygen to the brain (hypoxia).

PROGNOSIS: Hunt has accepted his last mission. After narrowly surviving multiple serious injuries, his luck would have run out when he electrocuted himself. Chest compressions and rescue breathing are not enough to resuscitate a patient experiencing cardiac arrest due to ventricular fibrillation. Without an electric shock from a defibrillator (not available on-site) or a second shock from the electrical wires to reset his heart rhythm, he would be dead.

 CONDITION: Deceased, with knowledge of his actions disavowed by the US Secretary of State.

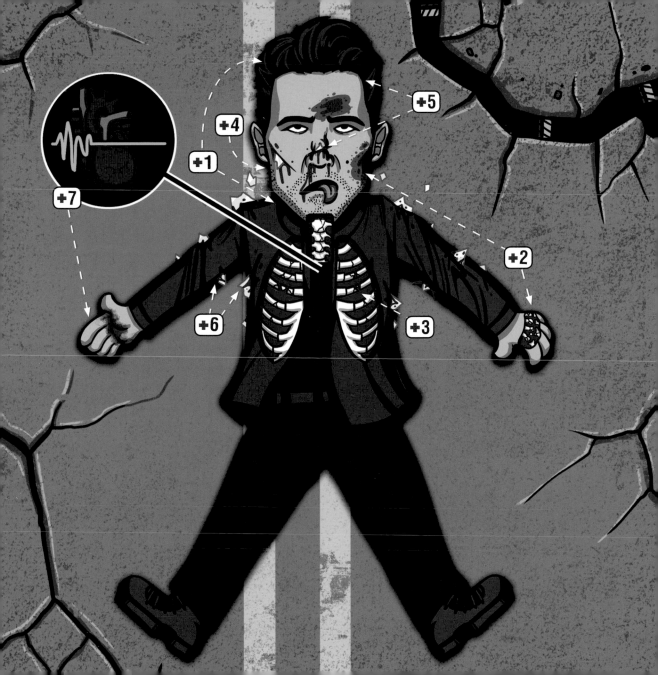

JOHNNY UTAH

 SCENE OF INCIDENT: *Point Break* (1991)

OCCUPATION: FBI agent

INCIDENT REPORT: Rookie FBI agent went undercover as a surfer to take down a ring of thrill-seeking bank robbers. Patient was shot twice, got into numerous brawls, and jumped out of an airplane without a parachute, yet still found time to catch some waves.

 INJURIES:

1. Lungs: Knocked off his board into turbulent surf. Inhalation of water could lead to eventual dry drowning.

2. Face, hands: Multiple fistfights. Superficial lacerations on face. Bruised knuckles possible.

3. Hands: Tackled suspect through a window, landing in broken glass. Later, punched out a picture window with his left hand. Probable cumulative class II hemorrhage from deep glass incisions. Tendon and/or nerve damage likely.

4. Neck: Single-car accident with a tollbooth. Neck strain (whiplash) possible.

5. Left thigh: Jeans caught fire after being doused with gasoline. Contact with flames limited; possible first-degree burns.

6. Left knee: Jumped approximately ten feet into a concrete aqueduct, landing awkwardly. Minor medial collateral ligament (MCL) tear.

7. Abdomen: Shot twice with a Smith & Wesson 6906 pistol (9 mm caliber bullets). Ballistic (bulletproof) vest prevented critical injuries. Contusions probable.

8. Head: Hit with the butt of a handgun. Superficial laceration on left temple. Severe concussion with loss of consciousness.

9. Left knee, back: Jumped out of a plane without a parachute. Caught up to a parachute-wearing suspect by streamlining his body into a more aerodynamic position. However, when patient pulled the suspect's ripcord both men were too close to the ground to avoid serious injury. Reaggravation of MCL tear upon landing. Fracture of thoracic and lumbar spine (broken back) likely.

ADDITIONAL OBSERVATIONS: While playing football in college, patient's knee twisted ninety degrees in the wrong direction, resulting in a major MCL tear—an injury reaggravated twice while undercover.

PROGNOSIS: Recovery from reconstructive MCL surgery would take six to nine months, during which time most of the patient's other minor injuries would also heal. Tendon and nerve damage to his hands, however, could be permanent—not that Utah would notice much, as he would most likely be quadriplegic from breaking his back.

CONDITION: Paralyzed from the neck down. Gnarly.

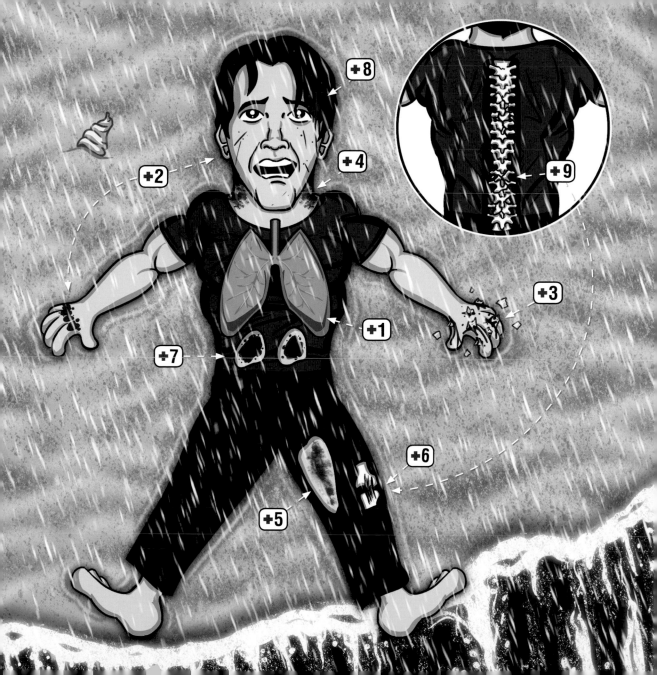

MAJOR ALAN "DUTCH" SCHAEFER

SCENE OF INCIDENT: *Predator* (1987)

OCCUPATION: Mercenary

INCIDENT REPORT: Ex-military soldier and his band of mercenaries were methodically hunted by an alien predator in the Guatemalan jungle. Patient was mortally wounded going *mano a mano* with the alien.

 INJURIES:

1. Right biceps: AR-15 SP-1 rifle exploded in patient's hands after being hit by a projectile from the alien's shoulder-mounted plasma caster. Fragment injuries (lacerations) to biceps. Class I hemorrhage.

2. Feet: Went over a cliff approximately eighty feet into a river. Probable calcaneus (heel bone) fractures due to feet-first water impact at a velocity exceeding 40 mph.

3. Abdomen (left side): Fell approximately twenty feet out of a tree. Fractured ribs. Hemoptysis (coughing up blood from respiratory tract) from internal crush injury.

4. Throat: Alien lifted patient up by the throat. Potentially severe tracheobronchial injury (crushed windpipe), which could obstruct patient's airway and lead to asphyxiation.

5. Mouth, hands, right wrist: Hand-to-hand combat with the unnaturally strong alien. Bleeding from the mouth (class I hemorrhage), with possible avulsed teeth. Dislocation of knuckles/bruising probable. Broken wrist likely.

6. Entire body: Alien set off an explosive self-destruct device. Patient attempted to escape the bomb's blast radius (estimated at around 2,700 feet) on foot, but only made it approximately three hundred feet from ground zero before the detonation. The patient would have either been A) immediately vaporized by the fireball, or B) mortally wounded by the blast wave, which would have caused fatal pulmonary barotrauma.

ADDITIONAL OBSERVATIONS: Patient covered himself with mud to avoid detection by the alien's thermal-imaging equipment. However, this could have caused his open wounds to become infected. Tetanus, anthrax, and necrotizing fasciitis (flesh-eating bacteria) are just a few of the many soil-related bacterial, fungal, and viral infections possible.

PROGNOSIS: Most of the injuries Major Schaefer sustained prior to the explosion would heal within four to six weeks, if given the chance—though if his windpipe were crushed, he would have likely expired then and there. That would have at least spared him a particularly ugly death down the line from either the explosion or—if, by some miracle, he survived—a lethal infectious disease.

CONDITION: Get to the chopper! Hopefully it's carrying a body bag for what's left of Dutch.

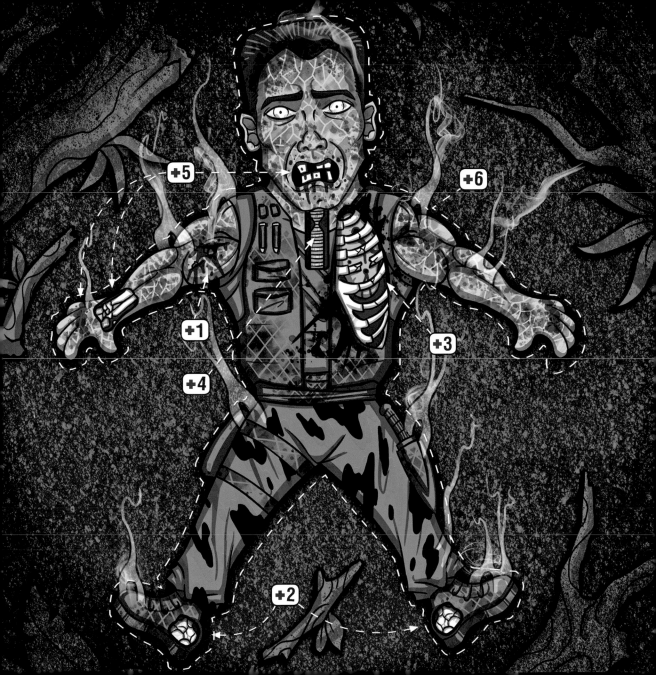

JOHN RAMBO

SCENE OF INCIDENT: *Rambo: First Blood Part II* (1985)

OCCUPATION: Green Beret

INCIDENT REPORT: Honorably discharged Special Forces soldier was temporarily reinstated for a reconnaissance mission to find POWs in Vietnam. Patient killed nearly sixty Vietnamese and Russian soldiers while sustaining only moderate injuries.

INJURIES:

1. Neck: Choked with a leather cord for twenty seconds. Later, choked by the hands of an enemy combatant for over a minute. Temporary cyanosis and impairment of consciousness due to mild hypoxia. Contusions on neck possible.

2. Entire body: Dunked repeatedly in a mud pit tainted with hog waste. Bit by leeches. Each bite mark would be an additional entry point into the body for infectious agents, including E. coli, salmonella, or MRSA.

3. Face: Punched twice in the face. Contusions probable. Severe concussion with loss of consciousness from the second hit.

4. Entire body, wrists: Electrocuted on an electrified torture rack. Involuntary muscle contractions and pain. Likely second-degree burns where current entered and exited body (wrists).

5. Left cheek: Branded with a red-hot survival knife. Superficial incision with no bleeding. First-degree burn.

6. Hands: Lifted a barbed wire fence with bare hands. Deep puncture wounds on palms. Class I hemorrhage.

7. Entire body: Knocked into a lake by detonation of an incendiary device (firebomb). Probable primary blast injury (acoustic barotrauma). Possible first-degree burns from heat.

ADDITIONAL OBSERVATIONS: Despite being fired upon by dozens of enemies, the patient returned from his mission without a single gunshot wound. While it's impossible to dodge a bullet, military history books are dotted with stories of outnumbered soldiers taking out entire enemy platoons (for example, Lieutenant Lawrence Dominic "Fats" McCarthy, an Australian soldier, almost singlehandedly killed twenty-two enemy soldiers and captured fifty others during World War I). With enough ammunition and a little luck, anything is possible—especially if the enemy has bad aim.

PROGNOSIS: Of immediate concern is the possibility of bacterial or viral infections, one or more of which could be antibiotic-resistant and require lengthy hospitalization. Rambo's other injuries would heal in six to eight weeks. PTSD symptoms—which the patient experienced after returning from a previous deployment—could re-emerge, requiring long-term management.

CONDITION: The war's got to end sometime for Rambo, but that time isn't now. Full recovery expected—at least physically.

JAMES DALTON

SCENE OF INCIDENT: *Road House* (1989)

OCCUPATION: Cooler

INCIDENT REPORT: Tough guy restored order to the rowdiest bar in Jasper, Missouri—and, by extension, the entire town. In addition to the usual fisticuffs injuries, the patient was shot, stabbed, and cracked over the head with a beer bottle. You should see the other guys, though.

 INJURIES:

1. Left shoulder, abdomen (left side): Moderate knife wound to shoulder. Later, cut with a blade across the abdomen. Deep incisions with cumulative class I hemorrhage. Patient treated and stitched the first wound himself; the second wound was stapled at a hospital.

2. Entire body: Multiple physical run-ins with disorderly patrons and thugs. Superficial lacerations on face. Epistaxis. Bruising and/or dislocation of knuckles possible. Bilateral periorbital hematomas (black eyes) likely. Fractured ribs possible.

3. Head: Beer bottle smashed over back of the head. Severe concussion with loss of consciousness. Superficial laceration probable.

4. Lungs, eyes: Ran into a burning house to save his landlord. Smoke inhalation. Possible shortness of breath, reflex coughing, and eye irritation.

5. Thorax: Struck with a log. Bruised or fractured ribs possible.

6. Left shoulder: Shot with a Taurus PT99 pistol (9 mm caliber bullet). Class I hemorrhage (class II if the bullet hit patient's brachial artery).

7. Head: Hit with a spear handle. Superficial laceration on left temple.

ADDITIONAL OBSERVATIONS: Patient killed an opponent by ripping the man's thyroid cartilage (windpipe) out with his bare hands. However, human skin has a tensile strength of over 2,500 pounds of force per square inch (psi), far exceeding what an average person can generate with their hands (approximately 40 psi). Instead of penetrating his opponent's skin, the patient's fingers would more likely be dislocated attempting such a maneuver.

PROGNOSIS: Once Dalton received emergency oxygen and fluid replacement for the cumulative blood loss, he'd be on the road to a four-to-six-week recovery. Given the litany of previous injuries listed on his medical chart—two gunshot wounds, nine knife wounds, and thirty-one broken bones—perhaps it's time for him to look into a less dangerous line of work. Philosophy, maybe?

CONDITION: Full recovery expected. Not bad for a skinny little runt.

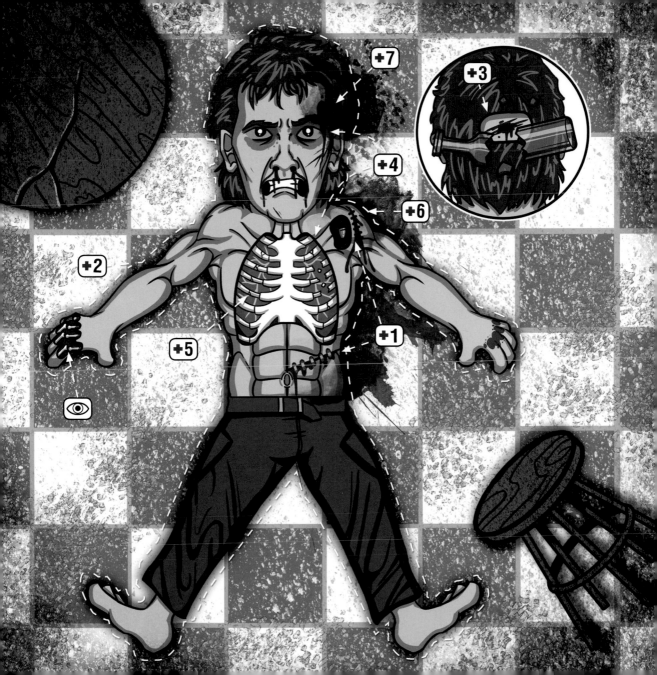

Dr. STANLEY GOODSPEED

SCENE OF INCIDENT: *The Rock* (1996)

OCCUPATION: FBI chemical weapons specialist

INCIDENT REPORT: FBI biochemist infiltrated Alcatraz to prevent a group of domestic terrorists from launching a poison aerosol attack. Patient got his first taste of fieldwork, which included fisticuffs, a car chase, several explosions, and near-fatal exposure to a deadly nerve agent.

INJURIES:

1. Neck: Plowed a "borrowed" Ferrari into multiple parking meters. Airbag deployment. Neck strain (whiplash) possible.

2. Ears: Dove underwater to avoid multiple explosions, which diminished the likelihood of serious primary or secondary blast injuries. Potential acoustic barotrauma.

3. Head: Thrown through a window. Later, tackled into a pile of broken glass. Probable incisions on scalp with class I hemorrhage.

4. Hands, wrists: Multiple fistfights. Superficial lacerations on knuckles. Potential fractured knuckles and/or wrists due to lack of hand-to-hand combat training.

5. Neck: Choked for fifteen seconds—not long enough to be severely injured, but contusions on neck possible.

6. Lungs: Exposed to Venomous Agent X (VX), a highly toxic nerve agent. Experienced respiratory distress (difficulty breathing), an early symptom of VX poisoning. Had he not received an antidote in time, he would have shortly succumbed to convulsions, paralysis, vomiting, and respiratory failure.

7. Heart: Patient injected 2 mg of atropine directly into his heart's right ventricle to neutralize the VX. Atropine side effects include dizziness, blurred vision, and rapid heartbeat (tachycardia).

8. Head: Thrown off feet by close-range bomb detonation. Primary blast injury (severe concussion with loss of consciousness due to the blast wave).

ADDITIONAL OBSERVATIONS: Intracardiac injection—of atropine or any drug—is quite rare, and for good reason: If the patient's aim was off, he could have punctured his left lung, resulting in a potentially fatal pneumothorax.

PROGNOSIS: Dr. Goodspeed would recover in a matter of hours from the antidote's side effects. Most of his other injuries would heal within six to eight weeks. However, the neutralized VX would remain in his body. The effects of nerve agents are cumulative—meaning that if the patient were exposed to VX or another deadly agent again, he might not have time to inject the antidote before his nervous system shut down.

CONDITION: Full recovery expected. Dr. Goodspeed will be back behind of the wheel of his beige Volvo soon enough.

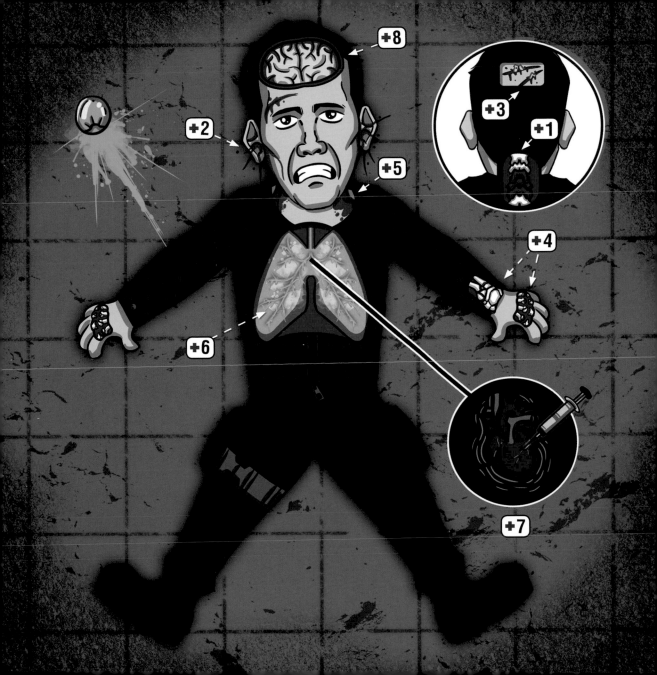

JAMES BOND

SCENE OF INCIDENT: *Skyfall* (2012)

OCCUPATION: MI6 agent

INCIDENT REPORT: After being shot twice, British secret agent fell hundreds of feet from a bridge and was presumed dead. Upon returning to duty, patient sustained further serious injuries while battling a cyberterrorist hell-bent on destroying patient's intelligence agency.

 INJURIES:

1. Pelvis, feet: Leapt twenty feet off a bridge onto the back of a train. Possible lower extremity injuries, such as pelvis and calcaneus (heel bone) fractures.

2. Thorax (right side): Shot with a Glock 18 fully automatic pistol (9 mm caliber bullet). Class II hemorrhage. Months after the entry wound had healed, patient cut out the retained depleted-uranium (U-238) bullet fragments with a knife. Increased cancer risk due to fragments' radioactivity.

3. Hands, thorax: Multiple clashes with adversaries. Bruised knuckles and fractured ribs possible.

4. Abdomen (right side): Shot with an Olympic Arms K23B tactical assault rifle (5.56 mm caliber bullet). Four fractured ribs and damage to several "less vital" organs. Class IV hemorrhage, resulting in hypovolemic shock and loss of consciousness. Possible bacterial infection from freshwater pathogens.

5. Entire body: Fell 335 feet into a river after being shot with the assault rifle. Simultaneous flexion and distraction of spinal column upon impact would cause spinal fracture of T12–L2 vertebrae (broken back). Drowning likely.

6. Back: Fell approximately ten feet into a dirt pit, landing on his back. Fracture of previously injured vertebrae possible.

7. Lungs, eyes: Escaped from a burning farmhouse. Smoke inhalation. Shortness of breath and reflex coughing probable. Eye irritation likely.

8. Lungs, heart: Submerged in below-freezing water at his family's estate for over sixty seconds. Probable "cold shock" with uncontrolled hyperventilation, cardiac arrest, and inhalation of water.

ADDITIONAL OBSERVATIONS: When patient "returned from the dead," he failed the MI6 medical and physical evaluations required for reinstatement. His psychological evaluation also revealed alcohol and (unspecified) substance addictions.

PROGNOSIS: No wonder Bond was presumed dead after falling from the bridge: Very few people survive falls into water over one hundred feet. When you add in blood loss from the gunshot wounds, there's virtually no chance he washed up onshore alive. Even if a miracle happened, he would later have drowned in the below-freezing water at his family estate.

CONDITION: Dead. Very dead.

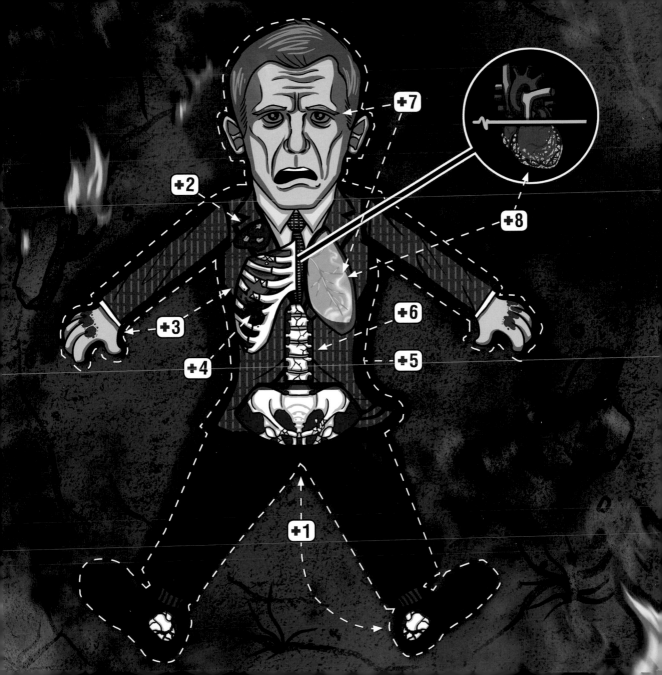

LUKE SKYWALKER

SCENE OF INCIDENT: *Star Wars: Episode V—The Empire Strikes Back* (1980)

OCCUPATION: Rebel Alliance commander

INCIDENT REPORT: Following a brutal attack by a wild animal, rebel fighter helped fend off an Imperial assault on the ice planet Hoth. Later, patient was seriously wounded on Cloud City in a domestic incident.

 INJURIES:

1. Head: Mauled by a wampa (a massive, yeti-like creature). Epistaxis. Deep incisions from the animal's razor-sharp claws, with class I hemorrhage. Severe concussion with loss of consciousness.

2. Entire body, face: Hung upside down in an ice cave for hours as a captive of the wampa. After escaping, patient walked miles across frozen tundra. Hypothermia (lethargy, weak pulse, disorientation, hallucinations) from extended cold exposure. Frostbite likely on exposed skin of face.

3. Neck: Patient's T-47 airspeeder hit by enemy fire, causing it to crash-land in snow. Neck sprain possible.

4. Face, right arm: Father-son lightsaber duel. Minor burns (reddened skin) on face from lightsaber's plasma blade, which appears to have a temperature in excess of 2,500 degrees Fahrenheit. The blade also sliced through the patient's arm, amputating his hand above the wrist. Wound instantaneously cauterized.

ADDITIONAL OBSERVATIONS: Cauterization was once routinely used to close off amputations. However, the procedure—which usually involves applying a heated metal object directly to an open wound—increases the risk of infection and is rarely used today. In this patient's instance, cauterization was crudely effective, preventing life-threatening blood loss.

PROGNOSIS: While the patient was fitted with a robotic prosthesis for his residual limb, he would not be out of the proverbial Endorian woods just yet. Cuts from the wampa's claws and burned tissue from the lightsaber wound would both carry a high risk of bacterial infection (treatable with immersion in a bacta tank). Most other injuries (neck sprain, minor burns) would heal within two to three weeks. Frostbite, however, would result in tissue death, necessitating skin grafts on young Skywalker's face—and possibly altering his appearance.

CONDITION: Partial recovery expected. To avoid future conflicts, family counseling recommended.

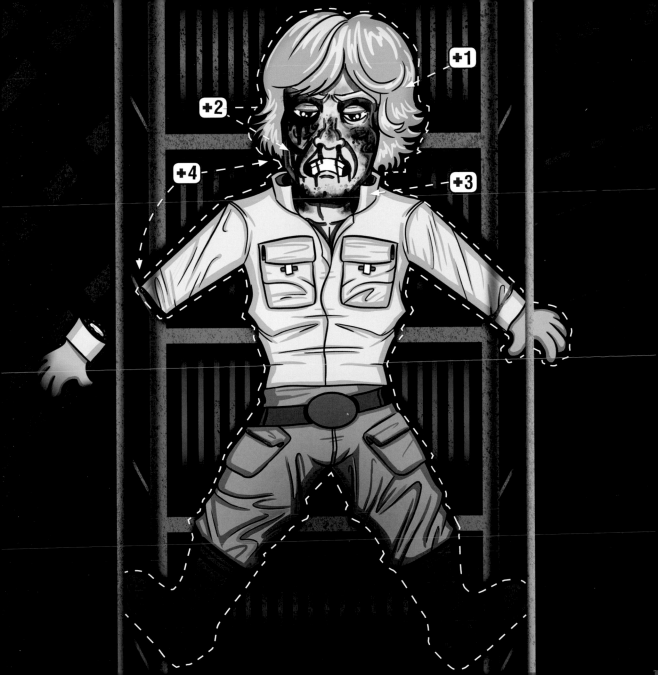

BRYAN MILLS

SCENE OF INCIDENT: *Taken* (2008)

OCCUPATION: CIA agent (retired)

INCIDENT REPORT: Patient's daughter and daughter's friend were kidnapped by Albanian sex traffickers while on vacation in Paris. Thankfully, patient possessed a very particular set of skills (including an uncanny ability to shrug off seriously painful injuries).

INJURIES:

1. Hands, face: Multiple fistfights with Albanian sex traffickers. Face slammed into the sidewalk. Bruised and/or dislocated knuckles possible. Possible zygoma (cheekbone) fracture from concrete impact.

2. Neck: Minor fender-benders with an SUV and a wooden shed. Neck strain (whiplash) possible.

3. Head: Clubbed on the back of the head with the butt of a gun. Severe concussion with loss of consciousness. Superficial laceration possible.

4. Neck: Choked with a belt for ten seconds. Possible contusions around patient's neck.

5. Abdomen (left side): Shot with a Heckler & Koch MP5K submachine gun (9 mm caliber bullet). Class I hemorrhage (with additional blood loss and increased risk of infection possible if internal organs were perforated).

ADDITIONAL OBSERVATIONS: Patient jumped through two windows, leading with his shoulder. He wasn't injured either time, however—not because he's superhuman, but because both windows were made of tempered (safety) glass, which shatters into thousands of tiny cubes instead of razor-sharp shards.

PROGNOSIS: Blood loss from the gunshot wound to the abdomen would require emergency oxygen and fluid replacement if Mills went into shock (especially likely if any organs were hit). While most of his other injuries would heal within a matter of months, his cheekbone fracture could result in a change to his appearance, possibly requiring reconstructive surgery.

CONDITION: Full recovery expected. Mills should be fully rested by the time his next family member is kidnapped.

SARAH CONNOR

SCENE OF INCIDENT: *Terminator 2: Judgment Day* (1991)

OCCUPATION: Resistance soldier

INCIDENT REPORT: Patient escaped from confinement at a hospital for the criminally insane with the help of her son and his time-traveling cyborg protector. Patient was critically wounded while clashing with a murderous, shape-shifting android.

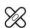 **INJURIES:**

1. Thorax, abdomen: Assaulted by sadistic psychiatric hospital staff, who kicked her and clubbed her in the abdomen with a nightstick. Fractured ribs possible.

2. Entire body: Tazed. Temporary paralysis, followed by stiffness and pain.

3. Left biceps, entire body: Injected with a 10 ml solution of sodium amobarbital meant to calm her into submission. Drowsiness.

4. Right shoulder blade, right collarbone, right lung: Stabbed twice with the shape-shifting android's mimetic polyalloy (liquid metal) blade. Deep penetration wounds. Cumulative class II hemorrhage. Tendon and/or nerve damage probable from one or both injuries. Possible penetration of right lung, which would result in a fatal pneumothorax.

5. Anterior right femur: Shot with a Heckler & Koch SP89 submachine gun (9 mm caliber bullet). Class II hemorrhage; potentially fatal class IV hemorrhage if femoral artery was hit. Noticeable limp, indicating probable tendon damage.

6. Head: Police van crashed onto its side with the patient unsecured in back. Superficial laceration on forehead. Possible skull fracture and/or intracranial hemorrhage.

7. Neck: Patient's pickup truck rear-ended by a semi. Neck strain (whiplash) probable.

8. Entire body: Crashed her pickup truck head-on into a forklift at high speed. No airbag or seatbelt. At a minimum, injuries would include blunt trauma to the chest and fatal compression of intra-abdominal organs.

ADDITIONAL OBSERVATIONS: Patient's doctor prescribed her the antipsychotic medication Thorazine (chlorpromazine) to treat her "delusional disorder." Though the drug may have had some sedating effect, it had no effect on her beliefs about time-traveling cyborgs, because—obviously—they weren't delusions.

PROGNOSIS: Most injuries would heal within four to six weeks. Tendon and/or nerve damage to patient's right arm and leg might not be repairable, leaving her with permanent loss of mobility in the affected extremities. Unfortunately, "permanent" wouldn't be all that long for Connor, as chances are she wouldn't have survived all three automobile accidents.

CONDITION: Terminated . . . in this timeline, anyway.

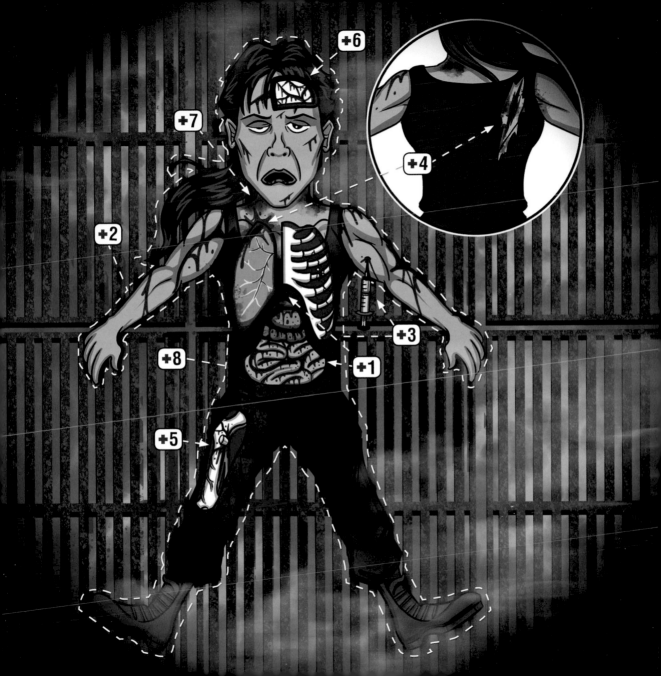

DOUGLAS QUAID

SCENE OF INCIDENT: *Total Recall* (1990)

OCCUPATION: Construction worker

INCIDENT REPORT: Patient learned his life was a lie after an aborted memory implantation procedure. Patient fought his way through a host of government agents en route to Mars, where he learned the eye-popping truth about his former identity.

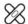 **INJURIES:**

1. Head: Suffered a schizoid embolism (acute neurochemical trauma) during a memory implantation procedure, causing him to temporarily recall repressed memories of his secret agent past.

2. Head, hands: Multiple tussles with secret agents. Severe concussion with loss of consciousness following a kick to the face. Bruised and/or dislocated knuckles possible.

3. Testicles: Kicked several times between the legs by a secret agent posing as his wife. Temporary pain and nausea likely.

4. Abdomen, left forearm: Cut twice with a steak knife. Superficial incisions.

5. Hands, face: Jumped through an X-ray machine's viewing window, shattering the glass with his bare hands. Shortly thereafter, dove through a broken glass window. Glass shards would cause deep incisions on exposed areas (hands, face), resulting in class II hemorrhage. Tendon and/or nerve damage probable.

6. Face: Extracted tracking device from cranial cavity via left nostril. Marked epistaxis and postsurgical swelling of nasal passage likely.

7. Right shoulder: Cut with a large gas-powered mining drill. Deep laceration with class I hemorrhage.

8. Eyes, lungs, entire body: Exposed to Martian atmosphere. Difficulty breathing and convulsions due to low barometric pressure and lack of oxygen. Temporary paralysis likely. After ninety seconds of exposure, patient was saved by an alien device that terraformed the red planet with an Earthlike atmosphere.

ADDITIONAL OBSERVATIONS: If Mars hadn't been terraformed, the patient's blood pressure would have quickly plummeted due to continued decompression, resulting in myocardial infarction (heart attack) and death within a minute.

PROGNOSIS: Besides possible permanent tendon and/or nerve damage, most of Quaid's injuries would heal within four to six weeks. Drill injuries are especially susceptible to infection due to the uneven nature of the tissue damage, so prolonged antibiotic treatment would likely be required. Long-term effects of the memory implantation procedure are unknown.

CONDITION: Partial recovery expected—unless the trip to Mars was a freeform delusion caused by the schizoid embolism. In that case, consider Quaid permanently divorced from reality.

Acknowledgments

Special thanks to the medical professionals and others who lent their expertise to this book, including Dr. Nathan Boles, MD, FACP, FSHM, Director Hospitalists, Memorial Hospital at Gulfport; national- and state-certified Emergency Medical Technician (EMT) Zoe Ahrendt; and J. D. Ramsey at Bluegrass Tactical Supply. Any errors, however, are the author's own.

About the Author

Andrew Shaffer is the *New York Times*–best-selling author of the essential survival guide *How to Survive a Sharknado and Other Unnatural Disasters*, as well as many other humorous and informative books.

About the Artist

From a young age in the cold mountains of Vermont, Steven Lefcourt knew his love of nature would lead him in one of two directions: science or art. He quickly realized that he would rather paint frogs than dissect them, and his path was set. Besides, he's pretty bad at math. Today he is an apparel designer and freelance illustrator in California.

References

American College of Emergency Physicians. *First Aid Manual.* 5th ed. New York: DK Publishing, 2014.

Feliciano, David V., et al., eds. *Trauma.* 6th ed. New York: McGraw-Hill, 2008.

Internet Movie Cars Database. www.imcdb.org. Accessed October 24, 2016.

Internet Movie Firearms Database. www.imfdb.org. Accessed October 24, 2016.

Internet Movie Plane Database. www.impdb.org. Accessed October 24, 2016.

Page, David W. *Body Trauma: A Writer's Guide to Wounds and Injuries.* 2nd ed. Lake Forest, CA: Behler Publications, 2006.

Rahm, Stephen J. *Trauma Case Studies for the Paramedic.* Burlington, MA: Jones & Bartlett Learning, 2004.

Sobieck, Benjamin. *The Writer's Guide to Weapons: A Practical Reference for Using Firearms and Knives in Fiction.* Cincinnati, OH: Writer's Digest Books, 2015.

INSIGHT
EDITIONS

www.insighteditions.com

 Find us on Facebook: www.facebook.com/InsightEditions

Follow us on Twitter: @insighteditions

Copyright © 2017 Insight Editions

All rights reserved.

Published by Insight Editions, San Rafael, California, in 2017. No part of this book may be reproduced in any form without written permission from the publisher.

 REPLANTED PAPER

ROOTS of PEACE

Insight Editions, in association with Roots of Peace, will plant two trees for each tree used in the manufacturing of this book. Roots of Peace is an internationally renowned humanitarian organization dedicated to eradicating land mines worldwide and converting war-torn lands into productive farms and wildlife habitats. Roots of Peace will plant two million fruit and nut trees in Afghanistan and provide farmers there with the skills and support necessary for sustainable land use.

Publisher: Raoul Goff

Associate Publisher: Vanessa Lopez

Art Director: Chrissy Kwasnik

Senior Designer: Stuart Smith

Senior Editor: Chris Prince

Managing Editor: Alan Kaplan

Editorial Assistant: Hilary VandenBroek

Production Editor: Rachel Anderson

Production Manager: Alix Nicholaeff

Library of Congress Cataloging-in-Publication Data available.

ISBN: 978-1-60887-978-6

Manufactured in China by Insight Editions

10 9 8 7 6 5 4 3 2